TH MOSAIC

ELIZABETH COOPERMAN

THOMAS WALTON

Sagging Shorts

© 2018 by Elizabeth Cooperman and Thomas Walton
Book design © 2018 by Sagging Meniscus Press

All Rights Reserved.

Printed in the United States of America.
Set in Adobe Garamond with LaTeX.

ISBN: 978-1-944697-66-2 (paperback)
ISBN: 978-1-944697-67-9 (ebook)
Library of Congress Control Number: 2018933824

Sagging Meniscus Press
saggingmeniscus.com

This book is dedicated to The Elba Nine (*L'Elba Nove*), who, along with The Writers of the Rome Mosaic, are Daniel, Mariel, Rick, Carol, Sarah, Maeve, and Tuuli.

Only her voice and bones are left, and then
Only her voice. Her bones are turned to stone.
So she hides in the woods and hills around
For all to hear—alive yes, but just a sound.

—Ovid's *Metamorphoses*

THE

LAST

MOSAIC

THE FIRST CONSPIRATOR to lunge at Julius Caesar was Tullius Cimber, who yanked at the dictator's toga from behind. Next Casca attacked, but the knife missed, scratching Caesar just beneath the throat. Caesar grabbed Casca's arm, then stabbed him with a pen.

I wonder what he wrote.

~

Among the ancient sarcophagi, ants crawl everywhere. Trailing in and then out, from room to room.

A bougainvillea climbs the facing wall of a courtyard nearby: an enormous spider waiting in the sun.

~

Newly arrived, we leave the Campo de' Fiori vowing to get lost. At each intersection we choose the narrowest, most forbidding way. After a half-hour we've succeeded, navigating a warren of narrow, crumbling walls. Another half-hour passes. Now completely lost, we turn a dark corner, duck beneath a low arch and find a terrific field opening out in front of us: littered with ruins and dazzling with lupines.

~

Soon this field won't impress us half as much.

~

In 64 AD, a fire ravaged Rome for six days. When the monstrous Emperor Nero rebuilt its infrastructure, most resources went into redesigning his own palace. Rumors spread that he had started the fire himself.

Nero's Golden House, as it was called, had a gold leaf façade encrusted with gems and seashells. According to Suetonius, inside were bejeweled, mother-of-pearl walls, fretted ivory ceilings, mosaic floors, large-scale frescos—depicting, for example, mythological abductions—and an indoor waterfall. Rose water could be piped through the ceiling, showering dinner guests in a fragrant mist.

Nero's new house sat amidst two hundred acres of gardens, fountains, vineyards, and bathhouses nestled between the Palatine, Esquiline, and Caelian Hills. In the center was a lake bedressed in grottos, gazebos, and marble columns.

Citizens and senators alike were aghast at the emperor's profligacy.

~

Why are we so compelled by the lives of the rich and the perverse?

~

After Nero became so hated that he was driven to suicide, Emperor Vespasian drained the lake behind the Golden House, and in a gesture towards the citizens of Rome, constructed the legendary Coliseum in the lake's footprint.

Latin epigramist Martial wrote: "What was formerly a tyrant's delight is now the delight of the people."

~

On our first night in Rome, we decide to leave the windows open, to hear "the song of Italy."

After several hours of drunken blabber in the street below, set to a continuous soundtrack of monotonous reggaeton, the recyclying trucks arrive and seem to be filling Bernini's *Fountain of Four Rivers* with every glass bottle in Lazio.

We never leave the windows open again.

~

Monte Testaccio is the ancient world's largest garbage dump, composed of the crushed shoulders, necks, handles, and bodies of about 250 million amphorae that once held olive oil brought in from the provinces. Once emptied of oil, they were destroyed.

John Keats' grave lies at the foot of Monte Testaccio, now surrounded by chic sushi bars. *Testaccio* means "potsherd."

~

We graze through the gravel, collecting shiny bits of obsidian to display in a jar on the coffee table later.

~

"How astonishingly does the chance of leaving the world impress a sense of its natural beauties on us . . . I muse with the greatest affection on every flower I have known from my infancy." (John Keats to James Rice)

~

During the reign of Augustus, when Rome was seven hundred years old, Livy penned the story of the birth of the Eternal City. As he tells it, Rome began as a war between brothers. When six vultures flew across the Aven-

tine Hill where Remus perched, Remus assumed he'd
won the crown.

But then twelve vultures sailed over the Palatine Hill
where Romulus crouched, revising the story.

The matter not settled by the gods, Remus scaled the
still unfinished wall his brother was building on the Pala-
tine. Enraged, Romulus murdered his twin.

Rome begins with murder. And murder will be its
national anthem.

~

I will stare hard so that castle on the crowded bank never
floats away.

IN THE MORNING when I open the window there's whistling, church bells, the wasp of a scooter, restaurants setting up for lunch, and the repetitive "Buon giorno!" big and round and full of vowels, of owls.

~

The mosaics in the Villa Giulia employ such small pieces of fractured tile that they almost seem to be oil paintings . . . almost. If you stand back twenty feet or more, they *are* oil paintings. As you step closer, the cracked assemblage reveals itself. Fish lurch, Gorgons tremble, a squid twitches.

I imagine that if you hold a microscope up to an oil painting, it too is a kind of mosaic?

~

Our apartment comes with a stove-top percolator and a pound of ground coffee. Also, some other, less important things.

There's a window in the kitchen that looks down onto a courtyard, and an orange tree on the balcony below. Our first fight is about whether the tree is real or not. This fight, like most things here, will both end in ruins and never seem to end.

~

The word *paragone* means "comparison." During the Italian Renaissance it referred to the debate for superiority among the art forms: that is, painting, sculpture and architecture. Mosaic never really had a chance, and might not have even been in the race.

Beginning in the third century BC, mosaics were used in the Roman Empire for floor and wall decorations. The mosaic as fine art continued well after the fall of Rome, when Byzantine artists used them to portray the story of Christianity.

~

I dreamt last night I was a fountain in the Tivoli Gardens. Fast streams of forceful water poured from my breasts, my ass, my vagina. I reached to try to stop the flow, but my stone hands were fixed to my sides. The water poured and poured, and I could do nothing to stop it.

The best dream I've ever had.

~

When you look close enough, there's nothing that isn't a cracked assemblage.

~

The sound of cicadas is deafening here. Here where the plane trees lift up only to hang down, far over the levee walls of the Tiber.

Plato suggests that cicadas were men who became so engaged in singing that they neglected to eat or drink. Their bodies wasted away. What was left, what *is* left is this endless song, seeming to ring out of thin air.

The Greek poet Xenarchus perhaps understood them better than Plato. He knew, at least, that it is only the male cicada that sings, attempting to call a mate. He quipped, "blessed are the cicadas for they have silent wives."

~

Psychological studies have proven that the brain will make up a coherent story instantly from seemingly disparate information. This is why haiku is compelling. And, too, why fragments are engaging.

Why would anyone long to be understood? No one's interested in what they understand.

~

A fragment defies the mind's impulse to make things whole. Defies it, and entices it.

~

"The video camera was zippered into a bag, still on, and it recorded only blackness and a few points of light shining through the canvas." (Eula Biss)

For some reason I think of cicadas like this, somewhere out of sight. Something like voices singing in another room.

~

Something, perhaps, like Frost's "abstract vitality of speech." "The best place to get the abstract sound of sense is from voices behind a door that cuts them off."

Actually, the best place is along the Tiber, the voices of cicadas behind an antiquity that cuts them off.

~

I'm pretty sure Frost didn't mean "cuts them off." He meant "muffles them." What is cut off from the language is referential meaning. What remains is its music . . . its music and its tone.

~

Gordon Lish claims that all a writer needs is one strong sentence. If you can pull that off, and you can hear the nu-

ances of that sentence, then the next sentence will spring from the music of those original sounds.

A kind of variation on a theme. You can write a whole book this way, seeming to ring out of thin air.

~

While photographing the bottle caps, cigarette butts, and broken glass stuck in the cobblestones, he says, "I think you could beachcomb in the streets here."

The cobblestones seem somehow to whisper. How could they not? Why wouldn't they have as much or more to say as the cicadas singing or swallows, the plane tree boughs scritching the levee walls and seagull laugh.

~

Mosaic shares an Indo-European root with Muse, museum and music; and more broadly with muster, summon, premonition, and monster.

~

At the Porta Portese flea market, I'm strolling along, eyeing the crappy antiques, when a vendor calls out, "Hello, Madame Looking!"

"Buon giorno, Signore Vendendo."

The man is Pakistani. He doesn't laugh. I buy two shirts from him. One that says (on the back): "Never let me go." And another: "This girl likes patches."

~

The cobblestones are mostly made of porphyry. They are the tesserae of the mosaic that is the city, spotted here and there with ruins and churches, that filthy wound of a river worming through its core.

~

Tessera is derived from Greek, meaning "four." To tessellate is to form into a mosaic pattern.

I might say Rome but what I mean is more.

~

"What makes life life and not a simple story? Jagged bits moving never still, all along the wall." (Anne Carson)

~

On the flight, a little girl cries in Italian about the pressure in her ears. In the central medallion, I eat the beef—horrible gas. Hot towels. Tiny toothbrushes. Behind me, old people snore. At the outermost border, a guilloche of clouds.

~

Illustrated in black tile, two armored fish one tessera away from touching lips.

~

A mosaic in the Palazzo Massimo depicts a cat with pulsing eyes and arched back trying to catch a bird. Each hair on the cat's tail, back, and scruffy head leaps out tense and articulate from the others. You can feel electricity running through it. The picture defies its stilted material.

The effect comes from *opus vermiculatum*, a mosaic technique used to highlight central figures. Working with square micro-tesserae and contrasting, in this case, the cat's black hairs against a solid white background, the artist achieves a halo-effect around the cat.

Opus vermiculatum means, literally, "worm-like work."

Worm-like work. I'd like to burrow inside you for the next thousand years.

~

Writing imitates other media that express things better. Please feel free to cut these out and arrange them pictorially however you like.

IN THE MUSEUM I overhear a professor say: "at home I see a few beautiful things; in Rome, if you make a frame with your fingers, and point it in any direction, you'll find something beautiful inside it."

He probably lives in Ohio.

The umbrella pine's hands hold up the sky, while the cypress seem to shoot from the ground. Hooded crows terrorize a pigeon crippled by disease. The traffic cops wave their flattened caps at racing dogs.

. . . if you make a frame with your fingers.

At the Doria Pamphili we stop at a pond where a hundred turtles climb over the top of each other trying to get at little bits of bread some children are throwing at them. Each newly arrived turtle fights, then pushes the previous one beneath the water, then is replaced by another, another. A stack of turtles. A pile. Some nuns in blue habits wander up, smile, watching the scene. One takes a selfie with her friend, turtle mayhem in the background. I feel like I'm in some ring of Dante's hell.

This happens a lot in Rome.

~

It's not difficult to imagine King Kong and Godzilla fighting in the streets here, leaving the Baths of Caracalla to wrestle through the wide expanse of the Circus Maximus, the Coliseum repeating arch after arch in the distance. They, too, would probably be lost.

~

It's true that all roads lead to Rome, but once you're there, who knows where the hell they lead.

STANDING IN FRONT of the bronze she-wolf (sixth century BC) in the Capitoline Museum, I realize I'm ill-equipped to feel antiquity. What, after all, is the difference between 500 BC and, say, 100 AD? My brain understands, but my body can't calibrate it.

~

The she-wolf is everywhere in Rome. As it should be, as it's suckled the city these three thousand years. Her teats dripping conquest into the mouths of baby Romulus, doomed Remus.

Poor Remus, who chose the wrong tit. May as well have drunk the filthy scum of the Tiber.

~

Sarah Manguso says that to compensate for the speed of life—the raw data ceaselessly piling up—the diarist wishes for non-days she could spend recording her yesterdays. That is, non-days between the lived-days. Mortar between the tiles. I've written the same thought down in how many journals?

Especially in a place like Rome, a city that resembles a color I once heard described as "a riot of the senses." The smells alone are enough to cause a riot.

~

There was the vine, the latticework along the stucco wall, and a hundred butterflies ruining the poem.

~

"If one starts looking, there is much to see. But if one glances merely, there is nothing but a pathetic little room with unimposing, half-obliterated, scratchy little paintings in tempera." (D.H. Lawrence)

~

I lean toward the she-wolf, put my head against its side, listening. What I'm listening for I'm not exactly sure.

I'll let you know when I hear it.

I BROUGHT D.H. Lawrence's *Etruscan Places* in preparation for our trip to Cerveteri and Tarquinia. I'm not a big fan of Lawrence, especially his tedious descriptions, but appreciate it when he gets nasty. Like when he's comparing Etruscan art to painter John Singer Sargent, "who is so clever. But in the end he is utterly uninteresting. He never has an inkling of his own triviality and silliness. One Etruscan leopard, even one little quail, is worth all the miles of him."

I'm not much of a Sargent fan either, though people have told me the figure in his painting *Nonchaloir* looks "exactly like you." The figure leans back in Etruscan repose.

~

Pool balls of hay in the field. Thousands of sunflowers giggling in the breeze.

~

Etruscan black-figure pottery (seventh to fifth century BC) became a vehicle for spreading knowledge of the Greek myths and epics. In terms of documentation, humanity was mostly living in an image-language rather than a written one. Some of us still are. Or rather, are

again. The written word has not been so neglected since perhaps the Dark Ages.

~

A glowing green lizard bathes on the pocked stone, content as costume jewelry, until we gravel in and send it grumbling into the hide of the oft-looted tomb.

~

Outside the tombs, let's call it the streets of the necropolis, the cicadas' incessant cry invokes the voices of the dead singing somewhere off in another room. I'm not sure how to read its tone.

~

The temperature drops with each step as we descend into the unadorned tombs at Cerveteri. The porous, tufa walls seem to be breathing. Nothing else is. Sound echoes and vibrates so that anything you say reverberates in your chest.

Deep inside the tomb, blackberry vines struggle to find light. A bird feather, tip-down, stands in the dry pine needles.

Sound echoes, but really there *is* no sound. No one dead is speaking.

~

At one point we're in a high atrium leading to a pitch-black room. The air issuing from it—no, the lack of air issuing from it—is so cool I feel like we could stay here forever. I'm afraid, perhaps, we have. That we've been duped into thinking we'd come as visitors, as tourists, but in actuality have died and are here to stay.

~

Can air be a lack of air? A fallow void from which all oxygen has been sucked. Sucked from the tombs and sucked from the lungs.

Lungs are tombs.

~

I saw only once a swallow fly into one of the tombs, as if by mistake. It never came out.

~

Lawrence imagined that for the Etruscans life on earth was so good that they felt life after death would simply be a continuation of the life on earth. Thus the tombs were full of bowls and hairpins, pitchers of wine, etc. And the paintings on the walls of the tombs were joyful, there was no trauma, no hell associated with death.

~

At Tarquinia, you move up and down between the flat, sun-blasted world and the underground tombs "like a rabbit in a warren." In Lawrence's time, you could wander down into the tombs with a flashlight and examine the frescos. Now, plexiglass at the bottom of the stairs blocks you from getting close to the chalky explosions of color. A button on the wall turns on a light inside the tomb, timed to stay on for sixty seconds or so, illuminating the coquettish pose of a lioness, head turned back, tail flipped up, or the lunge of the horse on a red, lidded pot shaped like a laundry hamper, several dancing musicians leading the deceased down to the underworld. Then the light goes out, as if it all were just a dream.

~

The Tomba del Morto is badly damaged. But "on the broken wall are the dancing legs of a man, and there is more life in these Etruscan legs, fragmented as they are, than in the whole bodies of men today." (Lawrence)

~

I don't think I'd mind spending the rest of eternity in one of these tombs. At least, I wouldn't mind being painted onto the wall.

~

A rectangular pattern that resembles blueprints of cat-
acombs within catacombs—a system of interlocking
rooms—frames the ancient figures in front of me. I look
at their robes, spiny beards, and naked breasts. If we
replaced these bodies with our bodies, we'd be in top-
knots and yoga pants doing poses in gyms built on top
of parking garages.

~

In the Tomba della Caccia e della Pesca, a balletic war of
blue and red birds, above which a party rages in full ink.

~

Imagine baked rock, wildflowers, dry grass, yellow spunk
on cave walls, cobwebbed brush, piles of brown leaves,
white-tipped pinecones, swallows like flying tuxedo bows,
an annoying fly, the quick rattle of a lizard—dark green
and spotted, now frozen on the wall.

And then, always, the cicadas, which are giving me a
headache. They grate against the air, ripping it to pieces.

Socrates imagined that cicadas watched humans to
see if they were honoring the muses. In that unbearable
heat, I'm not sure they would have given me a good re-
view.

~

Why do we think dogs were entombed with their masters and not the other way around?

~

Across from a sad wall, porous and dotted with moss, I sit down for a minute and catch my breath. The lizard returns, this time moving slowly, crawling parallel to the ground or diagonally up, its tail longer than its body. It starts and stops.

Tourists move through the tombs. It's not clear whether they're interested or not. They sit on big rocks, check their phones, drink from water bottles, then descend again into the tombs in their checked shorts, Hawaiian dresses, and rubber-soled sandals.

Sometimes I hope that they never come out. I'm sure they wish the same of me.

~

We love to think that various spaces are haunted, as we ourselves are haunted spaces.

Usually tourists prefer to eat *al fresco*, under giant shade umbrellas, mist spraying down onto them and their *cacio e pepe*. We soon realize that most al fresco restaurants have bad food.

~

In the Pincio Gardens a man comes up to us and gives us each a small red rose. We say thank-you and then he disappears with my wallet.

I'm pretty sure we got the better of the deal.

~

The best thing about a bad restaurant is a carafe of cold, white wine. It's even better than a good restaurant without one.

~

After dinner it's nice to rent a chariot and race around the Piazza Navona, the smell of horse ass close and warming.

In GREEK CULTURE, the grape vine was sacred to Dionysus, who in his most archaic form was a deity of the sap of plants, the "lifeblood" that causes them to emerge from earth each spring.

Both the sap of the vine and the press of the grape.

~

In Ovid's *Metamorphoses*, Pygmalion sculpted a woman from stone. He named her Galatea, caressed her, talked to her, brought her gems, pebbles, drops of amber. He put rings on her fingers and pearls in her ears. He found her so striking that he fell in love with her.

One day, returning home, he "fell on her, embraced her, and kissed her / Like one collapsing in a desert / To drink at a dribble from a rock." He found that the statue had become human, "Warm / And soft as warm soft wax— / But alive / With the elastic of life."

~

Dionysus wears a crown of bonbons. In French, *casser les bonbons* means "to get on the nerves," and a *bonbonne de gaz* is a gas can.

Caravaggio's *Sick Bacchus* is probably the ugliest Dionysus, and one of the most beautiful.

The same, of course, can be said about Caravaggio himself.

~

Psyche is derived from the Greek meaning breath, life, or soul. *Not* mind.

The Greeks also associated the word "psyche" with the words for "a departed soul or ghost." This is why she's often portrayed with a butterfly's or moth's wings.

Why she's always dressed in green is more difficult to say. After Eros left her, Psyche tried to drown herself in the river. The reeds along the river banks? The green water? Seaweed?

~

Everyone thinks that if you look into Medusa's eyes you'll turn to stone. But that's not how it works. It's the eyes of the snakes wreathing her head that will turn you. Medusa herself is a weeping center ruined by horror, a kind of bonbon.

~

omeone must've punched this Pan in the nose. His heavy arms unable to fight off assailants. Some sort of pastry where his genitals should be.

~

Apollo is the most beautiful girl I've ever seen!

~

The marble draped over his waist slips and falls just as he reaches his hand around the tree, still as yet unformed, running. The marble draped over his waist slips as he reaches around the tree, unformed, running. The marble waist slips around the tree, running. The marble slips, the tree running.

~

When she looked at me, I turned to stone.

~

Circe, what keeps your robes on now that your hands have been gnawed away by time. Found at the bottom of Tiberius' pool. Buried only for an instant. What really is

2300 years? Mere swine to someone like you, whose lips still entice, though half your chin is gone.

~

I'd like to bring back the shoelace hairstyles of naked Venuses. It's shocking how beautiful they are. You could almost starve to death in front of them.

How can *I* earn the ire of Aphrodite?

~

When he turned to me, I looked at stone.

~

I can only tell you that, now, being stone, it was much nicer to feel, to walk in the cool evening grass outside the museum . . . this goddamn museum!

Still, I would look at her again a thousand times.

~

Today I tried out a yoga class at a hotel near the Ponte Sisto. It was me and two older women, one I think was Kathy Bates. The teacher wore white palazzo pants, long beads, and metal bangles, and wanted us to channel our snake energy. We started cross-legged, our torsos stirring

round and round in big circles. "Relax, don't force anything," the instructor kept saying.

"Now," she said, as we stood up, widening our stance, "you hold a bow in your hands . . . and ready an invisible arrow . . . now set the target of your life . . . now release it."

I puffed myself up and imagined I was Athena draped in her scaly, golden goatskin aegis, affixed with a Gorgon head and dripping with snake tassels.

~

The boy Hylas was raped in a fountain by water nymphs, and then "rewarded" with immortality. Not sure if mentioning this on the signs advising tourists to stay out of the Trevi Fountain would be effective or not.

~

When he turned into me, I took his stone.

IN THE PIAZZA COLONNA the soldiers o
fight forever, wrapped around the col
Straits' "Sultans of Swing" spirals up
eating *arancini*; a man smiles and w
in swami robes.

I'm not sure who to throw my euros to.

~

"The active religious idea [of the Etruscans] was that
man, by vivid attention and subtlety and exciting all his
strength, could draw more life into himself, more life,
more and more glistening vitality, till he became shining
like the morning, blazing like a god." (Lawrence)

I'm pretty sure Lawrence is imagining things here, but
who cares. It's a great idea!

~

Unexpected, specific, and perfect. It's nice to be in a city
where you walk around a corner and find glowing orange
swami robes hovering over the cobbles, some sort of god
or clown covered up inside.

.HE AMPHORA the dancers spin, their spidery hair .ued back and knotted into proud scorpion buns. Without flute or nipples, they leap through the underworld.

~

Plutarch wrote of mystic purification rituals thought to preview the singing and dancing that would happen in the next world, in Hades. These dances were rehearsals for death.

~

Pollux claimed that many of the names for ancient dances alluded to imitation—the *geranos* (crane), the *maktrismos* (kneading-trough).

The *skôps* (owl) involved the twisting around of the neck like an owl "which is caught when stunned by the dancing."

~

Dance scholars have studied ancient vase paintings of both people and animals searching for clues about dance forms and gestures now lost.

According to scholar Yana Zarifi, the performance of ancient dance is largely irrecoverable.

~

The figure in front of me is naked, slouched on a dolphin's back *nonchaloir*, like he does this all the time. He plays a flute. The arch in the dolphin's neck is peculiar. It's decorative, expressive.

Is this how you tell a dancing body from a static one?

~

Wrestlers frozen acrobatically in a beautiful valley of fighting bodies. A tall woman with a spear, her head like two other figures in the painting turned stage left in a complete, skin-wringing twist.

~

In the museum we imitate the poses of the figures on the black pottery. I lift my knee, my arm above my head. A security guard watches us intently. I smile but he's not amused.

~

Fruit is always spilling on the heads of dancing satyrs riding lions through the music heavy air.

~

In the ancient world, a "pantomime" was a single, masked male dancer who acted out all the parts of a tragedy, accompanied by music and song. His mask had no mouth, unlike ancient Greek theatrical masks. Pantomimes were described in inscriptions as "actors of tragic rhythmic dance." Lucian called the incredibly popular pantomime plays "a form of rhetoric by visual means or a philosophy articulated by the hands."

~

Panto + *mimos*, meaning "imitator of everything."

~

Pantomime dancers achieved a kind of rock star status similar to that of gladiators. Both were immortalized in graffiti.

Graffitied on a tomb outside the city walls of Pompeii: "Here's to Actius, come back to your people soon."

~

Once she leapt and twirled to the music from a double flute, but now her broken arm is the rabbit ear of lost dance.

32

~

Recently a partnership through the University of Binghamton tried to reconstruct the Roman pantomime form. A composer wrote music to tell the story of Narcissus. A single dancer played Narcissus, Narcissus' mother, and Echo. The performer wore three costumes and three masks.

I found a recording online. It was ghastly, nearly unwatchable. There was something about it that made me want to vomit—the arching, undulating, iguana-like body of the masked dancer and the insipid background opera.

Either it was a poor resurrection, or the Romans had a hideous sense of entertainment.

~

Anne Carson says it's wrong to think we're similar to the Ancient Greeks, that all you get when you study their culture is "little glimpses, little latches of similarity embedded in unbelievable otherness."

~

To know the dance, ask:

How do the reeds tilt? The hoof pause? How spread is the warrior's gait? How does the torso twist above the

pelvis? The spotted leopard arch, the horse bend to kill the serpent, the blue lion's tongue hook the air? How does the warrior whoop, his breasts round as a woman's? The dolphin bow to enter the dark purple cloud below, and the spotted gazelle leap, then spill around the lion's jaws?

~

We have lost the Etruscan language, and their dances with it, yet every statue in the Palazzo Massimo is spinning round whispering reeds.

AT THE MUSEUM a security guard sits next to a second century marble sculpture of *Baby Hercules Strangling a Snake Sent to Kill Him in His Cradle.* The guard has a red-tailed mermaid tattoo on his forearm and lazily scrolls through his phone. Hercules seems amused rather than frightened.

Upstairs, the torso of *Discobolus* twists in the anatomically realistic style mastered during the Early Classical period, muscles straining as he sets to hurl the discus in his hand right through the leaded glass of the museum window.

It's good to ask yourself: will I be flesh turned to stone, or stone turned to flesh?

IN THE CAPITOLINE I overhear a professor say the Romans are often accused of (and dismissed for) being copyists. She argues that Rome didn't have the same fetish for originality that we have. "Who plays the violin?" she asks. "Do you try to put your own stamp on Beethoven?" There's a pause. The students have that vacant student-look . . .

"Really?" the professor throws up her hands. "No one plays the violin!"

~

During the High Classical period, 450 to 400 BC, sculptors developed the contrapposto stance, a highly natural posture. The body weight of *Doryphorus*, circa 440 BC, is distributed onto one leg while the other rests easily behind him.

Michelangelo's *David*, 1504 AD, is perhaps the most famous contrapposto pose. This posture was fundamental to sculpture until the twentieth century, that is, for more than two thousand years!

~

It is a mistake to think that our minds somehow control our bodies or our emotions. The body runs the show, the mind is merely engaged in damage control.

~

Ancient Roman kings adopted the clothing, scepter, and throne of Etruscan kings.

Roman priests borrowed Etruscan methods of divination and augury.

Roman farmers adopted Etruscan practices of tilling and draining the land.

The bloody theater of the Roman Coliseum sprang from the sacred theater of Etruscan sacrifice.

~

Every poet knows that poets steal. Mimicry is the great device of art.

~

Michael Taussig's *Mimesis and Alterity* discusses mimesis as an adaptive human behavior prior to language. He suggests that the capacity to mimic our surroundings, to establish a "porous" relationship with the natural world, may be essential to our survival.

"The human being, to the Etruscan, was a bull or a ram, a lion or a deer, according to his different aspects and potencies. The human being had in his veins the blood of the wings of birds . . ." (Lawrence)

~

My sketches of restorations of Roman copies of Greek originals.

~

The twisting of one's neck like an owl. If you point it in any direction, you'll see something beautiful.

~

Before the printing press, monasteries had scriptoriums where monks sat and copied manuscripts. Picture a large room of long-robed monks bent over the history of literature! You can see how the act of copying (and having the time to do so) must have been saturate with holiness—must have been a sacred, rather than a purely mechanical behavior.

~

An art teacher I had once used to love to tell this anecdote:

One day his daughter yells to him from the other room: "Dad, get me a piece of paper and a pen! There's a beautiful pigeon on the clothesline outside!"

"Just a second," he yells back.

"Dad! Hurry!"

"All right all right."

By the time he gets her the paper and pen, the bird's gone.

Now you see it, now you don't.

~

Beginning in the late second century the work of Catullus was lost. What we know of his poetry—a "new" personal poetry cast in colloquial language—comes from a manuscript called V.

V turned up in Verona in 1305. Two copies were made (O and X). One copy disappeared, but first it was copied twice (G and R). By the end of the fourteenth century V had vanished again.

~

Beauty is that which we want to repeat.

THERE'S NOTHING as loud, as ungraciously assonant as the sound of the recycling trucks breaking glass at five in the morning in the narrow, cobbled streets of Rome. Nothing except the echo off the stone of that sound, and the echo off the stone of the previous echo off the stone of that sound . . .

Of course, these echoes happen as if at once, simultaneously. Prose doesn't stand a chance at mimicking it.

~

There is no feeling inherent in language. The poetry in language is what makes us feel. We use *poetry* all the time, though *poems* are generally thought to be useless.

~

I woke up early one morning, to try to record the sound of the recycling trucks breaking glass. For some stupid reason, I thought it might be nice to have a recording of that sound, the worst sound in the world.

My phone proved incapable. The sound it recorded was more like wind than shattering glass.

Sound is wind.

Poetry is arranged sound in language, the wind in the words.

THE EMPEROR HADRIAN was Spanish. His Villa—"a frozen bonfire of color" (Eleanor Clark)—had an underground tunnel system so that he didn't have to see the servants moving about. So they wouldn't disturb his view of Antinous, the most beautiful boy in the world.

~

It was the first time an emperor had so openly been homosexual. At least, the boy was allowed to dine at Hadrian's table.

~

Clark: "Hadrian, a character more complicated than anything in Proust."

~

Looking at the model of the villa you begin to sense that each species of tree was chosen to signal something, a kind of spelling. They're grouped by type, sometimes in neat rows but other times in necklaces on a hill. The buildings, with their myriad arched windows, porticoes and columns, sprawl like a strange white typewriter over the blank, puce-colored land.

~

Ruins climb over ruins, mash down. Scraped again. Will you not leave this place alone? Roots below, sun above. What memories do these stones hold? Antinous belongs to me. Not the sun or soil or wind or rain.

~

I overhear someone say, "*questa é la piscina*," and then again, lingering over the second syllable in "*piscina*" each time. I imagine Hadrian showing his young lover the pool in just this tone: "*questa é la piscina*," and the decadence of that pronunciation.

~

Antinous wears pancake cloth. A little bottlenosed dog crouches at his left leg. He both recedes and is *in rilievo*.

It's impossible to know whether the Emperor Hadrian had him killed.

~

Perhaps Hadrian couldn't stand to watch the boy age. *Aah, sister! Desolation is a delicate thing.*

~

At the villa, tourists bored on a bench draw in the dust with the tip of an umbrella. Ho-hum, another day, another two-thousand-year-old villa in ruins.

The sky's the color of olive leaves, the very tips of olive leaves.

~

"It is the saddest place in the world." (Clark)

~

Cat-shaped rock. Brown moss grows over its eyes. Murder seems to have been just another thing to do on a Saturday evening.

~

Three umbrella pines, green as broccoli, watch over a sunflower field whose hundred thousand faces turn away. On a day sacred to Osiris, Antinous slowly sinks to the bottom of the river. Almost immediately, Hadrian makes him a god.

~

Old, dying olive tree marked with blue paint.

~

In Edith Wharton's "Italian Garden-Magic" I read that she was annoyed with American gardeners, who add a column here, a headless marble statue there, in order to "Italianize" their gardens. What's most important in Italy, she says, is that the garden and the landscape form part of the same composition. Americans don't seem to understand this. Italian gardens are meant to be lived in. The paths are wide enough for "two to go abreast."

As if on cue, at the villa I overhear a young American couple: "maybe we should get cypress trees for the house, honey . . ."

HERE WHERE Horace, Catullus, Hadrian, etc. came to visit the marbled halls, the frozen bonfire of cacophonous stone, we argue over who's responsible for leaving the oranges back at the hotel.

~

The train rattles south, sometimes wailing, kneeling through the Tuscan countryside heavy with sunflowers, olives, hayfields, gold scarves folding, rolling rows of grapevines running over the undulant soil to Rome, Rome where every square foot of earth has its mouth full of stone.

~

Cloud-grey pustules pimple mottled sycamore bark. Parrots cover a tourist's tent dress. Pile of nuns studies pile of turtles. Wind pushes dry, contorted leaf. Leaf catches in cobbles. Releases, saying "catch it it's pitch."

~

I have a long dream in which I'm hanging bits of history on a clothesline. After a while (several thousand years), we try to write it out in tiny words on a single brick in the Forum. A storm comes. We get lost somewhere in the middle.

"ROME IS MOST EMPHATICALLY not a museum city, preserved in a vacuum as an *objet d'art*," says Georgina Masson. Romans have always "ruthlessly" destroyed old structures to build new ones, often treating their legacy with "complete insouciance."

"For all Rome, both architecturally and in its way of life," says Masson, "is a palimpsest."

~

Palimpsest is derived from the Greek *palimpsestos* meaning "scraped again."

~

Critics often describe American Cy Twombly's paintings as palimpsests, a quality we can't separate from his 1957 relocation to Rome as a young man, his envelopment in this ruined city. Twombly's layered, half-erased canvases usually bear—overtop—some barely legible inscription from the annals of classical literature: a line or poem title from Virgil, Sappho, Catullus. A few squiggly words whispering at us from the offskip.

~

In the central canvas of *Goethe in Italy*, Twombly has written just that phrase, "Goethe in Italy," in cracked pencil-marks, over a wash of moss-green acrylic paint.

~

On a brick in the Forum, a minuscule message written in black marker: "Be impressed!"

~

On the hill on the wall in the Tomb on the Hill the olive trees wave in the forced breeze of a coming storm shadowing the corner, which has crumbled to the floor, a shrike seems to flutter over some missing shrew or sheltered rodent hiding in the field, in the field beyond the olive branches' drab tempera fading slow these thousand years on the hill on the wall in the Tomb on the Hill.

~

When they completed his Golden House, Nero exclaimed, "Good! Now at least I can begin to live like a human being!"

~

In the Forum, I rest under a shriveled olive tree. Dust breathes onto my purse as I study three open, brick half-

rooms in the arcade. Weeds poke through the brick walls, like the back of a sewing project. Only the room on the left has a ceiling—a bricked arch cloistering it. I imagine goods and horses in these now skeletal stalls. In front of the empty niches is a squat brick mound that now means nothing. Perhaps other bricks once connected it to the arched area.

~

"Is it a pattern that we see or only a random placement of those stupid little tiles." (Lyn Hejinian)

~

All three rooms have weathered over time, but indications of symmetry allow us to imagine that the middle and right-hand rooms also had arched brick ceilings.

What leg would archaeologists, anthropologists, linguists have to stand on if all form were asymmetrical? What puzzle would be solvable? Pattern is what they all have to work from. That which is built without symmetry will not be recovered.

~

Before the twentieth century, scholars took Sappho's fragments and filled them in with verse that followed a "Sapphic" meter and published the emended works as Sappho's. We are never not filling in verses, never not filling empty space with assumed bricks.

You can write a whole book this way.

~

But then again, if you build with symmetry, they will bring you back—incorrectly.

Do you want to come back?

~

At the entrance to the Golden House was a "colossus"— a 120-foot gilded bronze sculpture of Nero. The Emperor Vespasian removed Nero's head and replaced it with Apollo's.

~

Livy tells us that Romulus founded Rome by means of rape and fratricide. Then, one day, beyond Rome's walls, he disappeared into some clouds and was never seen again.

Numa Pompilius, his successor, was a god-fearing Sabine who established peace with neighboring tribes.

Third came Tullus Hostilius, who found glory as a soldier, smudging that peace in blood.

And so on they went, and so on it continued, scraping Rome again and again, scraping it to the bone. And then still it went on.

And then still it goes.

THE SHAPE of the Piazza Navona follows the outline of an ancient circus. A racetrack which, somehow, in winter, the state would fill with water. There they would execute their prisoners of war via elaborately staged "sea battles," the tumult of the crowd rising up, swooping in and out, around the obelisks stolen proudly from Egyptian kings, still here today, the obelisks and the noise, the swallows swooping in and out just like they've always done.

~

The marquis is missing its poster, so the crumbling wall exposed advertises "ruinous building here . . . now!"

~

Shelley composed much of his poem *Prometheus Unbound* at the Baths of Caracalla. The day we were there was a July afternoon. The grass was dead, the heat intolerable. The umbrella pines did their best to provide shade, but mostly failed. Vendors were selling plastic bottles of water, panini. Empty bottles and wrappers were scattered about. Workers were setting up for some kind of festival. They'd erected a stage with a giant inflatable Bugs Bunny hanging off the front.

I found it difficult to find profound.

~

By sheer accident—they were excavating for a shopping center, I think—some construction workers found an ancient city under the new one. But this find was different. Everyone was still alive! Still alive and still complaining about how the new city wasn't really an improvement on the old one at all, in fact it was much worse.

ᴛʜɪs ᴘᴏᴇᴍ was chiefly written upon the mountainous ruins of the Baths of Caracalla, among the flowery glades and thickets of odoriferous blossoming trees, which are extended in ever-winding labyrinths upon its immense platforms and dizzy arches suspended in the air. The bright blue sky of Rome, and the effect of the vigorous awakening spring in that divinest climate, and the new life with which it drenches the spirits even to intoxication, were the inspiration of this drama." (Shelley)

~

The bricks here are terra cotta, baked earth. The mortar is coarse, near to concrete. Behind the bricks a slurry of rubble is thrown to fill the hollow. The corners alternate long / short / long / short / etc. Each joint is uniformly spaced. Every corner perfectly straight. Every face plumb. The faces of the bricks are hewn as opposed to molded, their chatter marks imply a blunt tool rounded to a point.

Is it possible the faces of the brick were "antiqued?" An odd gesture for an ancient ruin. That at some point in time, the builders were worried it might look "too new."

~

In the apodyterium, I took forty-three liberal paces, secretly measuring the distance across the dismantled room of the ruined bathhouse. A woman crossed back the other way, tracing my steps in reverse. She was crying. She stopped two thirds of the way through. I watched her from the opposite stairs.

She'd sobbed three different times, and still had a third of the way to go. She was larger than me, that is, she filled the space in a larger way. I mean, *she was more alive.*

~

When you look close enough, there's nothing that isn't a cracked assemblage.

~

The baths of Caracalla, I guess, are an ancient Roman YMCA.

Gift for the body? Or yoke for the mind?

~

A placard at the Baths describes the two most famous statues found in the Frigidarium (a large hall with pools of cold water), the so-called Hercules Farnese and Hercules

Latino: "The notoriety of these statues was so great that they were replicated in every size, from that of the actual statues of three meters to terra-cotta copies of only a few centimeters tall."

~

I watched a cloud, enormous in the sky above me, float slowly through an arch in the calidarium, now no larger than a cottonwood seed.

~

Julia Domna's hair is drawn back, resembling a dog pillow. The earlobes just show, just barely.

As Empress Consort, Domna was famous for her intelligence, and for patronizing the arts, music, and philosophy. She was Syrian, and gave birth to two emperors, Geta and Caracalla. Caracalla gave birth to the Baths, and the Baths gave birth to Shelley's *Prometheus Unbound*. *Prometheus Unbound* is mostly now ignored.

Her "footsteps paved the world with light, but as I passed 'twas fading . . . Aah, sister! Desolation is a delicate thing . . ."

In the gallery I was trifling over one of those contemporary modern sculptures, thinking about how "Calder" is surely derived from the Latin for "hot." I was aware of *The Boxer* at rest behind me.

His gloves on. His elbows on his knees. The cuts in his face. The "infibulation" of the male member. The lovely fish-scale skin . . . no, gasoline-like . . . no, street-lamp night a bronze can be.

I was aware of him—and he, I think, of me—but couldn't bring myself to look him in the eyes, though he'd been waiting two thousand years.

~

Until the Late Classical period, in the fourth century BC, sculptors generally remained anonymous. It simply wasn't a consideration to identify the sculptor. This, of course, is implausible to us. We're a culture that can't carve a Galatea without posting "look at me I'm Sandra Dee!" on Facebook long before it's even finished.

~

"The remarkable color effects seen on *The Boxer* were achieved by using copper for the lips and nipples, the drops of blood and wounds, and the hems of the gloves. The bruise under the right eye was created with an alloy

containing less tin and more lead compared to all the alloy of the main casting. The color of the bronze used for the bruise verged on dull red, which stood out from the pale yellow of the surrounding complexion."

"The eyes, which are missing, must have been of different materials, such as ivory, semi-precious stones or glass pearls."

~

"Infibulation of the male member," I later found out, refers to the practice of pulling the foreskin up over the head of the penis, and clasping it to one side. It was considered dirty to show your glans penis. Only slaves and barbarians would do that.

The Greeks, too, had their own puritan sensibilities. We're all of us a bunch of lunatics!

~

Ancient artists were identified not by name but for their greatest works: as in, "*Pittore della Nascita di Atena*" or "The Painter of Athena's Birth."

Perhaps we can be "The Writers of the Rome Mosaic."

~

Pound: "Pull down thy vanity, I say pull down."

MUCH OF THE Ancient Greek sculpture that has surviⱱ
exists only because the Romans copied it. Greeks work
mostly in bronze, a material that anti-pagans later melted
down for reuse. Romans generally preferred marble. The
largest, most prized Greek bronzes were hauled off, dug
up, dredged from the sea and destroyed and/or melted
down for materials during medieval times. Sculpture least
valued by the culture was more easily lost, and so, ironi-
cally, had the greatest chance of surviving.

~

"A sculpture is something you back into when you're look-
ing at a painting." (Ad Reinhardt)

~

Bernini was said to have achieved, through chiaroscuro
effects, a sense of color flickering in stone.

~

Michelangelo contended that painting had to imitate the
3-D qualities of sculpture or it was worthless.

~

Canova's marble portrait of Paolina Bonaparte lounges semi-lasciviously on the first floor of the Galleria Borghese, its flesh soft and inviting as the sea. When the flirtatious Pauline posed for Canova, she did it almost nude, in the guise of Venus Victorious reclining on a couch with an apple clutched to her exposed breasts—scandalous for a woman of her status. The pose embarrassed Canova. It was her idea. He lit the stove so she wouldn't be cold.

~

A sculpture is something you bump into when trying to get away from an Ad Reinhardt painting.

~

A friend researching medieval Europe for a novel she's writing about Hieronymus Bosch says monks kept malachite or emerald on the table where they copied manuscripts, and when they got tired it was soothing to rest their eyes on green stone.

I tend to use alcohol for this same purpose.

~

At the Pincio Gardens, ants crawl into the folds of Dante's hat. Dante is everywhere. At least, his Inferno is everywhere.

~

No, I don't have a drinking problem. I was just blessed with the gift of drink.

~

"For me the greatest thrill of Rome was walking into the Forum, picking up a piece of ancient stone where it lay, and dropping it somewhere else." (Sarah Manguso)

~

We're unpacking our bags in Seattle. "Look!" she smiles, and pulls a cobblestone from her suitcase.

~

"do not move stones." (Sappho)

~

During the battle for Troy, Achilles kills the Amazonian warrior Penthesilea. He falls in love with her as she dies, and catches her falling body before it hits the ground.

I stare for long minutes at her marble torso in the Palazzo Massimo. She's headless, her cracked chiton reveals a perfect breast. The stumps of her shoulders imply nothing, the gnawing of Time.

When I walk around to the other side, I notice a thumb fused onto her back. All that's left of Achilles, all that's left of his love.

~

Roman dry-stack walls were called "cyclopean" by early archeologists, who thought that only a Cyclops could have moved the enormous boulders into place.

~

On a stone wall I pass every day, lions lazily chew on pinecone sprigs. Each time I pass they catch my eye, and each time I'm happy to see them.

~

One legend has it that Achilles made love with Penthesilea's corpse. Another that her dead body gave birth to his living son.

I'm starting to think that everything's true.

~

Weathered face matted, rotting beard muffles the talking statue. Referential meaning in ruins, only tone remains.

~

In the garden the stone pillar climbs up out of a gather
of mynah's grazing on the lawn, their yellow glasses make
a perfect mask. You wouldn't even know they carry the
dust of dead merchants in their wings.

~

On a weekend pilgrimage to the island of Elba, where
Napoleon was exiled, the boat captain suggests we jump
off and swim around "La Isla Paolina," a hill of rock sur-
rounded by shallow reefs, black sea grass, and European
tourists in plastic snorkels. On this awkward formation of
rock rising out of the azurite sea, Napoleon's sister used
to rendezvous with her lover. Hard to imagine, unless he
was half goat?

While swimming through the black grasses, over
sharp, protruding rocks, and around this blip in history,
I try to picture her face, the long bridge of her angular
nose.

~

Stone has body. Water: voice.

But, really, what is there that doesn't say a thousand
shining things.

~

The concept of swimming around her trysting island seems charming enough, though back on the boat the captain notices blood on the rope figure-eighted to the floor. There are nine of us aboard.

When he asks who's bleeding, we all say in unison, "I am."

~

Ritratto di Faustina Minore has dribbly lips and sagging eyes, a hint of leather ear hangs below a border of hard cone hair. She's carved in veal colored marble, but I can't eat another bust of these.

INSPIRED BY CICADAS (and stupidity perhaps), I ⟨
late one night to read Baudelaire's prose poem
Drunk" on the stairs just at the end of the Ponte Sisto
in Trastevere. The buskers stop playing music for my per-
formance. I read in English, not French or Italian.

"One should always be drunk . . . not to feel the hor-
rible burden of Time weighing on your shoulders and
bowing you to the earth, you should be drunk without
respite . . ."

When I finish, there is applause. I'm unsure how
many people have understood. And if they have, what
they've understood.

Of course, everyone's always drunk in Trastevere any-
way so it really doesn't matter.

~

By the time he retired, crowds were shouting in the moon-
light "Tiberius to the Tiber!"

Bougainvillea sepals and matted pigeon feathers float in a sad puddle near the sewer cover SPQR.

It's said that Keats was buried with Fanny Brawne's unopened letters. When we exhume his corpse, though, all we find is vulgar language in the poet's hand. "Here lies one whose name was writ in water."

I'm beginning to think his friend Joseph Severn is behind much of the mythology of Keats. I suppose I admire him for it.

A central fountain turns itself inside out, spills whipped cream into the stagnant pool of green meat.

Vulgar means, of course, "common."

I'm not sure I'd like being buried with the reminders of a tortured love affair, those letters nagging to be opened for all eternity.

~

Stephen Mitchell's translation of Rilke's "Archaic Torso of Apollo" has the memorable line: "to that dark center where procreation flared." C.F. MacIntyre's translation is more, well, venereal: "into the bright groins where the genitals burn."

Here are some more:

To that black hole where morning glory bloomed. To that secret place where happiness crawls. To that cool swamp from which lilies spring. To that dim lack where living begins. To that broken place from which morning rose. To that vacant loom where fabric wefts. To that hollow coup from which cities blaze.

You can write a whole book this way.

~

Then again, just because he was buried with her unopened letters, doesn't mean he hasn't opened them since.

~

The water laughs as it tells a joke on the stone. The stone frowns, annoyed, all day and all night annoyed.

Casser les bonbons, to get on the nerves.

~

ıe Palazzo Massimo the *Dying Niobid* is wrenched
< as if a hand has grabbed her by the hair. She falls to
knees. Apollo and Artemis whisper in the sound of
water splashing in a fountain in the courtyard, "kill her,
kill her."

~

Goethe wrote of watching the waves in Gaeta (just south
of Rome) and seeing in them a sort of palimpsest, one
writing over another. For all of time.

~

The captain wears a brown Speedo, tattoos of boat pro-
pellers on his calves, ropes around his forearms like
bracelets, red roses on his collarbones, and fish skeletons
on his thighs.

He's Tuscan. His English is good, despite asking if any
of us want a "piece of kitchen" when he means "chicken."

~

The water from the fountain falls; it's going shopping in
the pool.

~

The heavy boat churns through the waves laughing onto quiet sand where flapping red umbrellas sell balloons.

~

Bernini's boat is all sea inside and cobblestone out. Tourists linger on the Spanish Steps like sunflowers on a Tuscan hill.

Listen, there will be a time we'll be in a place where the very air never rings with cicadas, we'll be in a quiet place, a tomb-like place, trying to edit them into the poem, arguing about trying to edit them into the poem.

AT THE BEACH, most of the Italians are crowded around a TV watching the motorcycle race.

~

The insalata mista from the bar is mostly corn, very little insalata, almost no mista.

~

Negative capability can be thought of as seeing without a code explaining things. That is, no political agenda. That is, nothing didactic—"Didactic poetry is my abhorrence," wrote Shelley.

Lion eats deer. Deer is eaten by lion. That's it. Keep your morality out of it.

~

Old men play bocce beneath oak trees, ruins of the Roman theater nearby. No one's keeping score. There's no "irritable reaching for the truth."

~

My favorite philosophers are those that say "do nothing, only in empty time are the riches of clear thinking avail-

able to us." Such turncoats of the useful world line the leafy banks or laze beneath the arched bridges of the gray-green river, setting to work, busy as glaciers, laboring hard at doing nothing other than redirecting flow.

~

In the Piazza Navona, five or six pigeons gather in the shadows thrown across a pizza crust someone has tossed near the Bernini fountain that everyone it seems except Bernini had a hand in sculpting.

Borromini's San Carlo alle Quattro Fontane is the most beautiful church on the Quirinale Hill. I try to let the atmosphere impress itself on me. That is, I try to *be impressed.* The church is elegant, a harmony of line and space and seeming simplicity. The cloister beside the main chapel is an open courtyard, in its center a single, mostly dead orange tree contorted and uncared for. The emptiest space I've ever seen.

It's in this church that I suddenly feel pantheistic, that I could worship in any church in Rome. At least, as long as it's one of Borromini's.

~

Hello, Pope Innocentio, waving down at me in your garbage bag of bronze.

~

Christian works were not meant to represent harmony and beauty, as Greco-Roman sculpture did. On the contrary, the emaciated bodies and faces had to express despair and suffering in order to impress on the laity Christ's sacrifice and passion.

Art became didactic; culture declined.

~

Christian art in Rome began under the reign of Emperor Constantine and prevailed for a thousand years. It sought to tell bible stories and teach Christian values.

Evidently it was a great success, a fine basket for conveying apples and oranges.

~

St. Peter's has, I think, the best bathrooms in Rome. Simple and dignified and flooded with light.

~

Nostril of a sleeping pope. Halos proud on the wall. Selfies in the Vatican . . . really?

~

Bernini's Sant'Andrea al Quirinale is the most beautiful church on the Quirinale Hill. I try to let the atmosphere impress itself on me. That is, I try to *be impressed*. The church is decadent, a roil of flying baby heads giggling in its domes. Fishermen drop their nets into the choir in hopes of dredging up song. Rich in color and glowing with marbles, the fishing is indeed quite good here.

It's in this church that I suddenly feel pantheistic, that I could worship in any church in Rome. At least, as long as it's one of Bernini's.

~

The most successful religions have the most compelling stories. Nations, too, must have a narrative richness. Rome is Rome because of its history, that is, the stories we tell about it.

~

Who should we sanctify, and who should we bury under this floor to keep people coming back?

~

When Borromini discovered that one of his workmen was looting marble from the restoration project at the Lateran Basilica, he ordered the man beaten. The man died. Borromini was charged with the murder.

He, like Caravaggio before him, was exiled from Rome.

~

It's ironic that orthodox religion refuses to believe in evolution, when religion itself has evolved from apes. It's true

that pre-linguistic stories were mostly mimetic and/or strictly informative, based around food source, tribalism, courtship, territorial disputes, etc. Nevertheless, the stories apes were telling, and continue telling, engendered the stories we tell.

Sometimes I think it's closer to *residue* than to *evolute*.

~

What's taking so long for this church to turn itself back into a temple to the sun?

~

It's true that Bernini was never exiled. Not that he was a saint. After finding out his little brother was sleeping with the same woman he was—the wife of another architect—Bernini tried to murder him with a sword. The brother fled. Bernini calmed down, then sent his servant to disfigure the poor woman's face with a razorblade.

~

There isn't a single cobble in this town that doesn't know some ghost or other.

~

What has time asked of these frescos of Christ that have caused him to crumble and fall to the floor?

~

Here, you be St. Francis and I'll be the birds. Something between us will have to do the singing.

A SEAGULL with red eyeliner stands on a ledge on the Palatine Hill. Tour guides carry scepters topped with stuffed animals, leading packs of babushka-ed tourists through dry grass. The guides walk past the bird and point to some ruins in the distance. As they recite the history and significance of a round temple near the Tiber, the tourists lose interest and head toward the seagull with their phones, cameras. They find that they can get an inch from the bird's face and it won't flinch. One of them tosses the gull crumbs. Feet never moving, the bird jerks forward, catches the crumbs in its bill, and swallows. Everyone laughs and claps.

I'm unsure how many people have understood. And if they have, what they've understood.

~

Turtles gather in the pond, hoping the little kids feeding them will soon fall in.

~

Prepubescent child's shirt appliquéd with gold sequin flamingo skips by. *Lantas* shoot up then twirl down, glowing blue, green. Today's souvenirs are tomorrow's garbage.

"Oh the streets of Rome are filled with . . . baubles."

~

There will always be peddlers of tripe and kitschy garbage, even in the most beautiful cities.

~

Keats says "Beauty obliterates all other consideration." Have you considered walking across the city in one-hundred-degree heat, having eaten nothing but a *cornetto simplice*, six shots of espresso vermiculating in your stomach?

I'm sorry, but I'd rather eat that Caravaggio than look at it.

~

When the German kid throws a cookie into the pond, a thousand turtles climb into my mouth.

IN AN EXPLANATION of fresco painting, we're told that violet pigments were obtained through the roasting of natural earths and iron salts. These pigments were known as "*morello di sale*" (violets of salt).

~

I like the idea of natural and unnatural earths, though lately I've been swatting people when they use the word "unnatural"—a word that usually implies human interference. Why would offshoots of the natural be other than it?

~

"The garden is the house." (Clark)

~

Up in the trees, a claw of half-dried leaves, arthritic, grabs a painful shock of sun. Purple wildflower clumps dance in circles around the gnarled trunks of olive trees.

~

What's natural is itself a construct. Why couldn't nature be an offshoot of the unnatural?

It's in dark ages like this that religions start.

~

We watched the goose waddling, its lizard feet mawing the dry ground.

~

Along the road to Sperlonga, the umbrella pines catch the early morning sunlight. Dandelions gone to seed. The radio in the bus is bloated with commercials.

Many of the works of art we've seen in Rome have a sense of completion. They violate Picasso's idea that "all great art comes together, just barely." The fragmented Hellenistic statues are an exception. They have been damaged, cracked, buried in the dirt for a thousand years or more, and wear that trauma. The missing parts make the present parts that much more brilliant.

~

Jasmine vine grabs onto the sun-drunk palazzo . . . please, please grab onto me!

~

Heading south to Tiberius' grotto, where the Emperor dined with guests and sometimes murdered them for en-

tertainment, we drive along fields charred by fire. Euca-
lypts hang miserably, half-burned. There is a lot that's
missing in this landscape.

The bus window braids a garland of grape vines, pizza
ovens for sale, fields of busted, rotting watermelons, pink
oleanders pouring over guard rails, sunflowers.

~

Blue shutters open to white lace needlepoint curtains. A
shirt says: "Love in different colors." Black gum on the
stair.

~

I know it seems like we're poeticizing sunflowers, but re-
ally, they're everywhere ruining the poem. Vulgar as Keats
or cobblestones.

~

East of the highway is Mount Circeo (formerly Aeaea),
where Homer claims Circe held Odysseus captive for over
a year. There are a few roadside bars looking onto it now.
We stop at one. Only after getting our drinks do we notice
the seagull, hit by some vehicle days ago, rich, putrescent,
decaying with the garbage in the ditch.

You will never see these things again.

~

Why do the swallows ever stop circling? Why do you?

~

The beach where Pasolini had his genitals smashed and then was run over repeatedly by his own car, now has the best espresso and panini pomodoro anywhere up or down the Tyrrhenian coast. Some poets just seem to be blessed with that sort of thing.

~

At the Pincio Gardens, we watch a swallow bully a pigeon. The birds here get tangled in your hair.

~

Leaving Rome, the train stops at Ostia Antica before you get to the beach. The soil has been scraped away to expose the ruins of the ancient port. The waves gnaw at the coastline.

I suppose we all have a painting somewhere beneath us. If not only a cracked assemblage.

~

It's morning here in Italy. I say Italy, but what I mea
really is one rather neglected terrace, cracked brick spot-
ted in places with little or much pigeon shit. Looking out
past the domes of various churches—Santa this or Santa
that, each housing the somewhat dubious remains of cer-
tain individuals persecuted by the papacy in life, canon-
ized by it in death—looking out past the trussed domes
to the Umbrian countryside. Perugia maybe, or Narni—I
should know but it really doesn't matter. The cypress trees
shoot up from the blond hayfield earth broken by red tile
roofs, other churches, other trees. The Tiber drowses by,
dreaming I think—surely every river dreams of the sea.

I say Italy but this is what I mean: all that I can hold
and then put here. A fraction really, of a song. A truncate
vision of an illimitable thing. Still, it is Italy and I am in
it. The sun fills the valley below and I sit high above it,
in the shade of the hill, some oaks, on the terrace, cool
and pleasant now but soon to be unbearably hot, the day
already nearly ruined.

A PRESS I work with sends me an email. A disgruntled author has decided their piece was rejected not because of its lack of merit but because the entire press is sexist. The editor is asking all the contributors for advice "in dealing with this sensitive subject."

I realize then how nice it is to be away from the quibbling literati back in the States.

"Let's braid them a garland of Rome."

~

Off the Via Nova a dark stairway climbs. The pale limestone is broken in places by ferns and wild geranium. A moth flutters from flower to flower, carousing one after the other.

~

When all of the city went up in flames, Nero gleefully fashioned a stage in his palace and performed an epic song about the sack of Troy. He considered himself a poet, singer, harpist, and architect, and used to lie down with lead weights on his chest to strengthen his singing voice.

On the brink of suicide, Nero ordered his attendants to dig a grave for him, and to gather wood, water, and pieces of marble for the funeral. Then he wept over and

over into the dirt, "What a great artist dies in me!" cicadas by the thousands rising up from the ground.

~

Do you expect to be living two thousand years from now? No? Well, too bad. You will be.

~

Your parents are everyone who's come before you, and everyone who's with you now, regardless of age.

~

In the Capitoline Museum it strikes me that most of the sculptures seek to achieve a sense of grace, or at least are concerned with it. The same can't be said for most works celebrated now. It's as if, for us, aesthetic elegance is beside the point. This despite the fact that aesthetic elegance is the only thing that lasts.

Don't speak to me of content. What magician cares what animal flies from his hands as long as that animal is the most beautiful yet brought into the world?

Shelley's right, beauty *is* everything. The body must refuse to bend to the mind.

IN THE INTRODUCTION to his memoir *Conversations with Goethe*, German poet Johann Peter Eckermann describes his impulse as a young boy to copy down on paper the image of a horse on the carton of tobacco his parents liked to smoke.

~

By the time he got her the paper and pen, the bird was gone.

~

When asked by the Pope's courier to make a drawing for him, Giotto supposedly dipped his pen in red ink and made a perfect circle. "Am I to have no other drawing than this?" asked the messenger. "This is enough and too much," replied Giotto.

~

Seeing his promise as a painter, a teacher arranged to get young Eckermann out of the heath and marshlands where he was born and to Hamburg to work with a master. Eckermann's parents judged it a dirty and dangerous trade and advised their son against it.

They were peasants whose primary source of survival was one cow (while Eckermann earned money collecting fallen chestnuts to sell as goose food to "persons of opulence"). His parents thought of a painter "only as one who paints doors or houses" and worried the boy might break a leg or his neck, especially in Hamburg where houses were often seven stories high.

~

Vasari said that Giotto was "constantly driven by a natural inclination to draw on the stones of the ground some object from nature." Cimabue first encountered young Giotto in the countryside outside of Florence "drawing a sheep from nature upon a smooth and solid rock with a pointed stone."

 ~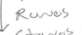

Beauty is that which we want to repeat.

~

You get a sense of how dark the Dark Ages really were when you hear that Giotto's frescos were considered revolutionary. Were they then *completely* dark? Evidently.

St. Francis' father wanted Francis to be an accountant. Apparently he thought preaching to birds in a field was impractical. There's no money in it.

Cezanne's father would agree, who had a "loving respect for money acquired by arduous toil, and an aversion for the 'precarious callings.'" He said to the young Cezanne: "Young man, young man, think of the future! With genius you die, with money you live!"

The father is gone, while Cezanne is still very much alive.

~

Before Giotto's time, painters used stock expressions. In Giotto's work, you can tell that he really looked at people's faces.

For a thousand years before him, the face hardly moved.

~

It's said that documents proving Giotto painted the frescos in Assisi were destroyed by Napoleon's troops.

Poor little Napoleon gets blamed for everything!

~

When you compare Giotto to his teacher Cimabue you can believe in the progress of art. I find in this transformation—towards naturalism and away from pure didacticism—proof that humans will always be able to see themselves out of dark ages.

~

There's a little confusion about when the mosaicist Pietro Cavallini lived and worked, but some claim he came directly after Giotto and was deeply influenced by Giotto's innovations.

The most famous of Cavallini's mosaics, his life cycle of Mary, is in the apse of the church of Santa Maria di Trastevere. This mosaic marks the decline of the art of mosaic. Cavallini's attempts to create a sense of how figures existed together in space, his attempts to use perspective in this mosaic as Giotto did in his frescos, expose the failure of this laborious and expensive artform to adapt to the artistic trends of the time.

This literally brilliant work—it flashes with gold—is not only one of the finest mosaics you can see in Rome, but a swan song for all mosaicists.

~

But then again, perspective alone means nothing.

~

When you compare Hellenistic sculpture to the art of the Christian era you can believe in the degeneration of art. I find in this transformation—toward pure didacticism, away from naturalism and aesthetic grace—proof that humans will always be able to see themselves into dark ages.

~

The boys were filling gas cans in the doorway of the barn, over which the lousy red horse pulled a plow across the sky.

~

This mosaic marks the decline of mosaic. It is both enough and too much. A swan song for all mosaicists.

~

Wait, remind me again . . . who did the Giotto paintings?

THE SADDEST CEILING in the world is in the Villa Farnesina, charcoal eyes of the boy crumbling slowly to the floor.

~

A skinny tourist opens his guidebook, holds it up in the air, dropping his head back and trying to match the map to the elaborate panels in Heaven, garnished with golden eggs and arrows, and paintings of a brutal war in soft pastels.

~

All day we flew around, swallow-like, busy at fulfilling our requirements. Triathletes of work, worry and food. When evening came we emptied our bags and realized that nothing of much value had been caught, we could have just been singing all day.

IN A CEILING FRESCO at Villa Farnesina, "Naples yellow" is used in Ceres' crown of wheat. It has a cold hue. A yellow with a cold hue.

Is there nothing that isn't cold in these old Renaissance villas?

~

There's a strange, irritating little Raphael painting in the Galleria Borghese covered in glass and, therefore, difficult to photograph. I draw it in pencil in my notebook, but the unicorn horn in my sketch is too long, the maiden's eyes too black, her bottom lip too big. I can't capture the girl's ocean-colored eyes, the absence of clavicles, the quiet, closed position of her mouth.

Neither can I capture the weird, open, mewling mouth of the little unicorn tucked under the girl's arm in the lower-left corner, its toy-like hoof hooked around her thumb, its almost translucent, nut-colored horn.

In 1959, radiography detected a dog under the brown, soiled-looking unicorn. You can still see the dog's ears on either side of the unicorn's head. They are little *pentimenti* smears in the woman's red velvet sleeves.

~

Raphael designed the fresco illustrating scenes from *Golden Ass* on the ceiling of the Cupid and Psyche Lo in the Villa Farnesina, though it was Raphael's numerous studio assistants who physically executed the work. Giovanni da Udine painted the elaborate garland twining all the way through the cycle.

Vasari described da Udine's garland thus: "a border of large festoons right round the groins and squares of the vaulting, making there all kinds of fruits, flowers, and leaves, season by season, and fashioning them with such artistry, that everything may be seen there living and standing out from the wall, and as natural as reality."

"As natural as reality" may be an exaggeration, but "right round the groins" is not.

~

The trick of art is to show the thing beyond the thing— to conjure, somehow, a ghost for the machine when that machine so obviously has no ghost.

On the pedestal: low growl from bronze wolf.

~

In the festoon: plum courgette aloe watermelon quince maize wheat bitter orange musk melon large musky

pumpkins cherry apple pomegranate cabbage water chestnut sweet chestnut sorghum common medlar peach pink vulgar roses.

~

According to a placard in an upstairs exhibit at the Villa Farnesina, XRF mapping "shows the presence of a wheat ear not recognizable in the normal view. It is a *pentimento*, that is, a detail covered by the painter in the final version of the painting."

A wheat ear.

~

Many wall cards in museums now proudly boast what scientists have found by X-raying famous paintings. Do we think that paintings were somehow spontaneously made whole, without some process of revision?

These "discoveries" are absurd. Painters work in layers, have *"pentimenti"* ("second thoughts"). It's as if we're surprised that the painting was actually painted.

It's worse, I think, in poetry. Two people go to Rome, type up their notes, call it a book . . . horrible!

~

"Whatever you have to say, leave the roots on, let them dangle, and the dirt, just to be clear where they come from." (Olson)

~

At Raphael's tomb in the Pantheon, Giuseppe De Fabris has made what seems to be a minor bust of the painter . . . until you notice the tears streaming down its face.

~

ILLE HIC EST RAPHAEL TIMUIT QUO SOSPITE VINCI RERUM MAGNA PARENS ET MORIENTE MORI.

~

"Here lies Raphael, Nature feared he would conquer her while alive, and she might die when he died."

~

Yes, I know he's a great painter, but I'll be happy to never see another one of Raphael's pink pastel parlor rooms.

BABUINO IS ONE of Rome's "talking statues." That is, one of the statues in the city that has historically been a place for citizens to comment on socio-political events. People still leave slips of paper and graffiti beside Pasquino, a statue just off the Piazza Navona.

In 2002, however, all graffiti was removed from Babuino, and an "anti-vandal" paint was applied around it. The retail stores in the neighborhood found that the political commentary distracted customers from spending money.

~

Even in the most ancient cities, the inability to escape the concerns of today blinds us to the lessons of yesterday.

~

Keats lived a few blocks from where Babuino now sits, or rather reclines. Consumption still plagues the area.

~

In the Capitoline Museum, he asks if I know where he can find Eros Sleeping? Because of his accent, I think he says "euros sleeping."

"No, I wish I did."

~

Gorillas here are replaced by tourists in the mist.

~

Babuino means baboon, and was so named because people thought it was a hideous statue, monkey ugly. It's actually a Silenus: half man, half goat.

The statue *is* ugly, but less so than the high end department stores surrounding it.

~

Beside the open window Eros sleeps, his arms too long to comfort us, his torso twists, he dreams of being whole, or wholly now awake, flying out over the loveless Roman streets, a hundred thousand hearts to destroy.

GLADIATING WAS POPULAR in the Coliseum for more than three hundred years. Paul McCartney also performed there.

~

Rome is a fine example of what a few men can do with an army of slaves. Christianity's genius is that it convinced the slaves to volunteer by hanging heaven over them. Slaves already, why not sign up for eternal life?

~

Is it true that the aesthetic outlasts the moral? That beautiful ends justify horrific means? Is this where you tie your pig? Beneath the arch, a lovely little bird gasping to death, its last breath in the latched sun.

~

During an enormous party at his Villa Farnesina, Agostino Chigi demanded that, rather than washing them, all the gold and silver plates used at dinner be thrown into the Tiber. The guests were astonished by this display of wealth.

After the guests had gone, Chigi ordered his servants to go get the plates from a net they'd hidden in the river.

~

Behind the bricked-in window, the filthy old pope looks out, smiling, happy with all that we've forgotten.

~

A crow lands on the heavy bough of a broad pine, whose skin cracks in the dry heat where they found the emperor's hollow bones. Bent yes, but unbroken, not a whisper of the hundred knives they say he took into the mouth of his back.

~

In 1350, the Black Death killed a third of the population in Europe.
 "There is no place that does not see you." (Rilke)

~

Oleander shrubs interspersed with sugar cane. Hay fields' talons latch onto the hills. Silos stitch a seam along the Tyrrhenian Coast. How much blood is in these corn fields spilling outside of Rome?

Julius Caesar was assassinated across from Feltrinelli, a bookstore that has a healthy selection of Pasolini's books, but not so much on Caesar himself. There is no bookstore across from the spot where Pasolini was assassinated.

~

At San Ignacio, a priest in black and white robes kneels at the tomb of San Roberto Bellarmino. The priest stares into the glass case containing a gold effigy of the Saint, who sleeps in vibrant red pajamas and pointed slippers with bows and brass balls.

~

"Aesthetics is the instrument we have to face the horrors of life." (R. Kenney)

~

Certain medieval popes had the penises scraped away from statues. What have we removed?

THE ANGEL'S HAIR slips like yellow moss from the h boiled egg he wears on his head.

~

Orlando Merlini's Gubbio Christ wears a hip-hop gold chain and ballet slippers, and holds out a perfect jelly donut. The most flaming Christ I've ever seen.

~

Caesar was killed in the Largo di Torre Argentina, where the cat sanctuary is now, a silver reliquary of hair.

~

The corpse was hoisted onto a bier and carried by torchlight to the burial site. Mourners surrounded the body with gifts, and his eyelids were reopened. One of his fingers was amputated, covered in earth, and buried, and the funeral pyre was lit. Once the flames died down, the deceased's ashes were asperged with wine, gathered up with his bones, and apportioned into an urn. The urn and the amputated finger were covered in three handfuls of earth and buried together.

You have to go to a lot of trouble when death is a sin.

99

~

Looking at various stone sarcophagi in the Palazzo Massimo, I realize that in a relief the imaginative figure literally emerges from the stone block, and that this is a metaphor for the creative process in general. It's an obvious idea, but still startling to behold.

With great art there's nothing that can prepare you for the thing you're about to see.

WHEN COMMISSIONING PAINTINGS, the Church liked to go through multiple rough drafts and conceptual sketches with artists. Caravaggio preferred the Venetian practice of working straight from Nature, meaning he didn't make sketches underneath—and no, none have been detected with X-ray technology.

~

I love the thin halos Caravaggio scratches into his paint. I wonder if he thought of Giotto being summoned by the Pope, as an audition for future commissions. The pope demands, "paint me something." Giotto proceeds to paint a simple, perfect circle. "You're hired."

I bet that never happened.

~

In Caravaggio's *The Calling of St. Matthew* you can hear the squeak of the bench rubbing the floor as Matthew's friends leap up, surprised that Christ has broken into the painting. Incredulous: "Who, him! You must be joking."

~

Unfortunately, Caravaggio lived his life like one of his religious paintings: ass and filthy feet in the foreground.

~

Write an epic poem called "The Police Reports of Caravaggio."

~

An artist's life is lived in the foreground. After death the art becomes the foreground. Life simply "moves to back."

~

Offskip: that part of a landscape that recedes from the spectator into the distance.

~

Language weaves a very good basket for conveying apples and oranges, but what of the sound of sunflowers turning in a dry Umbrian field? Or Caravaggio's last glance before being murdered by the Knights of Malta and washing up on the beach at Civitavecchia?

~

Caravaggio often used a technique called "tenebrism": a black background with a single light source.

In his painting *St. Francis of Assisi in Ecstasy,* the light and shadow are confusing. The underside of the angel's face is lit, but so is the top of his shoulder. And then

there's those little scratches in the offskip, dazzling from some other source.

~

Light: a quilted back, strip of side, a feather, a yellow buttocks, blink of kneecap, nipple of bent elbow, dripping old flesh, "*Lumiere*: 1 euro," sentences opening out.

Dark: a mouth-hole, smock, the every-other of a step, a fur detail of sleeve, little words (like "of" and "on"), inside the drape of a ribbon, soot on the feet, sentences turning in on themselves.

~

Language weaves a very good basket for conveying apples and oranges, but what of the sound of sunflowers turning in a dry Umbrian field? Or Caravaggio's last glance before being devoured by syphilis in a Sicilian brothel.

~

Early paintings by Caravaggio of men with lusty, bruised fruit, leaves hanging from the basket already browned.

His still lifes looked good enough to eat.

~

I wonder what Caravaggio's paintings do when no one's looking at them.

~

Light: Cavallini's life cycle of Mary, *cornetti alla crema*, morning sun on the Tiber, blazing like a god.

Dark: vermiculation between cobblestones, representations of Christ, drunkard on the Tiber, enraged as a god.

~

Language weaves a very good basket for conveying apples and oranges, but what of the sound of sunflowers turning in a dry Umbrian field? Or Caravaggio's last glance before dying of lead poisoning in his studio from his oil paints.

~

I did not see for fifteen minutes the trick of blood at the old man's waist training his white robes smocked in black velvet.

~

Caravaggio's painting *Zingara Che Predice La Ventura* translates literally to "Gypsy Predicting the Future," but

we have eliminated the gypsy (*zingara*) in all our translations. We call it *The Fortune Teller*.

It is, I suppose, more palatable.

~

Language weaves a very good basket for conveying apples and oranges, but what of the sound of sunflowers turning in a dry Umbrian field? Or Caravaggio's last glance, dying from malaria on the beach at Porto Ercole?

~

There was very little that was palatable about the painter's life, or the Rome in which he lived it.

~

In Caravaggio's *The Inspiration of St. Matthew,* the angel above him swoops down to recite to him what he is to write. The angel is in the shape of an ear.

Writing is listening.

AT FIVE A.M. Rome is mostly quiet. Quiet for Rome anyway. Swallows whistle, sea gulls laugh, a stray cat tears at a trash bag left out on the street, freeing a tin can and pawing it along the cobblestone as if to say "some music of some kind must always fill these streets."

~

Music is a circus and it is bread to me.

~

I can tell you what I need is one more afternoon in the shade of an umbrella pine, eating pistachios by the Greek Temple, studying our map of Rome, buses and parrots wheezing by. Each of us with some terrible song stuck in our head, each of us unable not to let it out.

It might make one in love with death to think that one should be buried in so sweet a place.

THE WORD "BAROQUE" comes from *barroco*, a Spanish word that refers to an oddly shaped pearl used in florid jewelry of the period.

~

Bernini must've laughed like a merman as he carved those little gold cherubs peeking down from the dome, guarding the tunnel between this world and that.

This world is never the problem. It's the *that*. What is it? A dove surely is an oversimplification of total annihilation. Still, it's a lovely gesture on a quiet morning, sirens singing outside in the street.

~

I could be that angel smiling in those golden rays of light, singing soft ecstasies to St. Theresa every night.

~

Bernini loves his rabid dolphins, foaming at the mouth, carrying some triton or other through the baroque fountains shuddering with selfies.

~

In the Galleria Borghese I overhear an art professor discussing Bernini's *The Rape of Proserpina*. I think he's trying to justify its aesthetic value, even though it "is a rape." He's defending it, and mentions that even though the word "rape" is charged with emotional energy at present, we should not trip up over it. We should not discount the work of art that has rape as its subject. He goes on to say that "abduction" is a much worse fate than "rape" because in an abduction you are subjected to rape innumerable times. He suggests that no one would object to the work if it were titled *The* Abduction *of Proserpina*.

"Now," he says, "would you rather be raped or abducted?" The group looks bewildered. Pluto's large, marble hand presses—for all of time—into the flesh of Proserpina's pillowy thigh, as he hoists her away on his shoulder. "I," says the professor, "would rather be raped."

I wonder how many other people in the gallery understand English.

~

Here's to Actius, go back to your people soon.

~

I like to think of a poem as a vertical thing, a silver shower tearing flowers down.

~

Of Bernini's translation of Ovid's story "Apollo and Daphne" into stone it has been said, "we may ponder which metamorphosis was the more miraculous, the god's or the sculptor's."

~

The Baroque is haunted by the Hellenistic just as the Renaissance is haunted by the Classical.

There isn't a single cobble in this town that doesn't know some ghost or other.

~

"This fleeting world in some way keeps calling us. Us the most fleeting of all. Once for each thing. Just once, no more. And we too just once. Just once, never again." (Rilke)

~

Wait, is that eight-foot ice cream cone outside the gelateria a Bernini?

~

I was thinking about the avant-garde and how that seems to imply a linear concept of artistic progression rather than a circular one—dark ages, renaissance, baroque, dark ages, renaissance, baroque, etc. We were wandering around the Quirinale Hill so went into Santa Maria della Vittoria to see Bernini's *St. Theresa* swoon in ecstasy. I was standing someway back and looking over the heads of art students and tour groups, not looking at St. Theresa necessarily, floating on her flowing robes, but at the little angel, spear in hand, smiling so delightfully to be giving her—Theresa—such ecstasy. It struck me—a strike not quite as striking as the golden light showering Bernini's marble, but still a strike nonetheless—that this angel represented the very essence of the artist at work when the artist is working well. And that none of it has anything to do with any other kind of movement at all—whether linear, circular, in marble or in moss—and talk of an avant-garde is mostly nothing more than five or six prattling gits trying to market their (often times richly myopic) work.

~

Like the Chiesa di Sant'Andrea, I too long to be rich in color and glowing with marbles.

AT THE KEATS MUSEUM, the conversation moves quickly to "the man behind the poems." A thing of beauty is a joy forever, rich with a sprinkling of fair musk-rose blooms.

His whole family died of TB.

~

Keats' "Endymion" was considered to employ foul language because it didn't speak in the language of the upper class.

Vulgar means, of course, "common."

As if the inanities of the upper classes weren't also common.

~

"Mr. Keats' hair was remarkable for its beauty, its flowing grace and fineness," wrote Leigh Hunt in 1883. You could almost starve to death looking at it.

~

Perhaps poetry is always "moved to back."

~

The docent at the Keats House tells us it used to be that poets spoke for everyone, that they used a universal voice. In the Romantic era, she says, poets begin to speak for themselves, about their own lives.

~

All that remains from Keats' days in the house is the floor, the ceiling and the fireplace. To prevent spread of disease, everything else was burned.

Keats' clothes, bed, and writing desk were all burned in the Piazza di Spagna, at the foot of the Spanish Steps.

~

There is a sea in Keats, that's what it takes.

~

The white marble bust of Shelley casts a blunt shadow on the red, floor-length curtain. How many hours did Keats stare up at this hideous ceiling, slowly dying, slowly realizing poetry wouldn't save him?

~

In Keats' day, if you had tuberculosis, doctors would perform "bleedings." They thought the body would regenerate itself with clean blood. Keats was given a bleeding, but it only weakened him.

~

During the early 1800s, tuberculosis killed one third of London.

~

Keats wrote to Charles Brown, "I have an habitual feeling of my real life having past, and that I am leading a posthumous existence."

~

Keats wrote to his friend Benjamin Bailey, "Twelve days have passed since your last [letter] reached me. What has gone through the myriads of human Minds since then? We talk of the immense number of Books, the Volumes ranged thousands by thousands, perhaps more goes through the human intelligence in twelve days than ever was written."

~

In Keats' day, if you had tuberculosis, doctors would perform "poetry readings." They thought the body would regenerate itself with fresh verse. Keats was given a poetry reading, but it only weakened him.

~

"O, for a Life of Sensations rather than of thoughts." (Keats to Bailey)

~

I'm sitting on the Spanish Steps with a thousand other tourists, killing time, crowding into the swath of shade cast by the buildings to our left. Bernini's Fontana della Barcaccia giggles beneath us. Everyone seems exhausted, sick with coffee and ancient masterpieces. Our faces lit by the glow of Keats' bed burning in the piazza.

~

In a letter to Shelley, Keats referred to himself as "the writer of Endymion, whose mind was like a pack of scattered cards."

~

In the preface to Shelley's elegy for Keats, the poet accuses Keats' critics of nothing less than murdering him:

"The savage criticism on his Endymion produced the most violent effect on [Keats'] susceptible mind; the agitation thus originated ended in the rupture of a blood-vessel in the lungs; a rapid consumption ensued . . ."

~

Last night I thought about Keats' "Ode to a Grecian Urn" stanza by stanza. After three stanzas describing a pair of young "unravish'd" lovers that will "never, never kiss," Keats pulls away to an entirely new scene. Suddenly, in this fourth stanza, we're examining the image of a cow—her "silken flanks" draped in garlands—brought to sacrifice in a quiet town. The fifth and final stanza returns to young lovers etched in marble. "Beauty is truth, truth beauty," Keats concludes famously. I decide the stanza about the cow is tangential. You could actually remove it and the poem would still work.

This morning, though, I like the fourth stanza after all: because to get to it, there is in effect a turning of the urn. The sacrifice scene has to exist on a different panel than the lovers frozen in their kiss, perhaps on the other side of the urn. Each of the two scenes is static, but the

urn has that slightly cinematic capacity to shift when the poet turns it.

~

". . . the poor fellow seems to have been hooted from the stage of life . . ." (Shelley on Keats' death)

~

In the Protestant Cemetery, I'm looking for Severn's grave. For some reason I think his headstone will give me some insight into whether or not he is the mythmaker behind Keats. Will he wink at me from beneath the soil?

While looking for Severn, I stumble across Gregory Corso. I didn't know Corso was buried here, buried it turns out, at the feet of Shelley. The angel of grief drapes over Ms. Emelyn Story nearby.

I imagine Corso stewing six feet below, in his legendary spite, his spleen now nearly quiet beneath the simple slab—surely he didn't choose those platitudinous lines. Someone had placed a shell beside "the death of me / endlessly / like a river unified."

A shell? I certainly don't think of shells when I think of Corso. Something more like a ragingly mad moon screaming fast, light trailing comet-like behind, across the flat-black Nimbin sky, where I heard on the ABC that he'd died, and all his bitter spume set free to lay siege to

any sleeping city anywhere. One more sack of Rome, I suppose.

~

"It might make one in love with death, to think that one should be buried in so sweet a place." (Shelley)

~

When I do find Severn, interred next to his friend, there is no wink, just an orange cat rubbing itself against his grave. Carved in low relief on Severn's headstone is a painter's palette and brushes. Keats' stone has a matching relief of a Greek lyre, with four of its eight strings broken.

It's interesting that Keats' name can be found on Severn's grave, while the poet is identified on his own gravestone only as the "One Whose Name was writ in Water."

There is no sign from Severn, no wink, no nod to say that I'm right, nothing. Just the endless ring of cicadas singing in the other room.

Now I Am Ready to Tell How Bodies Are Changed Into Different Bodies

IT OCCURRED TO ME that I may never be in that city again, so walked down to the river and then along its banks. The people in bars, restaurants, the music much louder than I'd ever heard it, a crass of scarred sound. I walked on, defending myself against the selfie sticks, wondering why anyone would want to see *themselves,* where I tried to burn the image of the uplit bridges forever into the membrane of my eyes.

The perfect circle that each arch makes with its reflection. I wonder if, when I leave here and reflect on having been here, Rome will be as lovely and as perfectly complete.

Shining like the morning, blazing like a god.

Not this city per se, but this pack of scattered cards.

When the Visigoths stormed the Pantheon, that immaculate round temple with its oculus and its dome, they rode in on horseback. They galloped round and round,

the sound deafening, all eyes—horses and riders' alik
lifted up to the hole in the dome where the heavens
through.

~

Will we, too, be buried by these unopened letters? Or can
we find a way out?

~

Tilling the land I found everyone who tilled before me.
Writing the poem everyone who wrote before me, happy
to be released.

~

All day the sun worked to shift the light in the city, ev-
ery minute a new angle, so that when we returned later
that day to the overlook it would seem new, and be new,
and we could let our eyes down into it as if we never had
before.

I HEARD THERE was a god where the statue used to sit, or rather lounge Etruscan style, eating artichokes and staring across the piazza. The statue's gone, though the colossal niche remains, frightening for its emptiness, its height as well as depth. They found the left foot of the statue—also enormous—buried nearby, several hundred years ago.

They say the god still haunts the place. Whether in the niche or near it no one seems quite sure, but pilgrims still offer flowers, little notes in Italian. The giant foot is now in one of the museums across town.

I go to the niche to see if I can sense any divine presence, but mostly just to have something to do. That is the nice thing about a pilgrimage: it's an end from which to produce means. I find nothing, really. Some ferns in the wall have loosened the stone, which has crumbled down to mix with the trash and weeds on the ground.

"God?" I say, but feel nothing.

"Divinity?" I say, thinking maybe polysyllables will be more effective.

"Force more great than I will ever comprehend?" Still nothing. No perfect being conceived. No manifestation of creation. No personification of natural force. Only a seagull laughing, gliding over the plane trees along the Tiber.

I walk away a little disappointed, but also happy to have my search still intact. It's best not to find the thing you're looking for.

References

a tyrant's delight *[p.3]* Christopher Hibbert, *Rome: The Biography of a City*, quoting Martial, The Epigrams, trans. James Michie, 1978

The video camera *[p.9]* Eula Biss, *The Balloonists*

The best place to get the abstract sound of sense *[p.9]* Frost to John Bartlett, July 4, 1913

What makes life life *[p.11]* Anne Carson, *Plainwater*

Writing imitates other media that express things better *[p.12]* A line that bubbled up in conversation with Richard Kenney, and taken here as a challenge.

to compensate for the speed of life *[p.15]* Sarah Manguso, *300 Arguments: Essays*

If one starts looking *[p.16]* D.H. Lawrence, *Etruscan Places*

deity of the sap of plants *[p.24]* Museum wall text, Villa Farnesina

fell on her, embraced her *[p.24]* *Tales from Ovid*, trans. Ted Hughes

Pollux claimed *[p.30]* Yana Zarifi, "Chorus and Dance in the Ancient World", *The Cambridge Companion to Greek and Roman Theatre*

According to scholar Yana Zarifi *[p.31]* ibid.

Lucian called the incredibly popular pantomime plays *[p.32]* A.K. Petrides, "Lucian's *On Dance and the Poetics of the Pantomime Form*," *The Cambridge Companion to Greek and Roman Theatre*

Graffitied on a tomb *[p.32]* Mary Beard, *Pompeii: The Life of a Roman Town*

Beauty is that which we want to repeat *[p.39]* Richard Kenney once said this was at the core of Zadie Smith's novel *On Beauty*

frozen bonfire of color *[p.41]* Eleanor Clark, *Rome and a Villa*

two to go abreast *[p.44]* Edith Wharton, "Italian Garden-Magic," *Italian Villas and Their Gardens*

Rome is most emphatically not a museum city *[p.46]* Georgina Masson, *The Companion Guide to Rome*

When they completed his Golden House *[p.47]* Hibbert, quoting Suetonius in *The Twelve Caesars*, trans. Robert Graves

Is it a pattern *[p.48]* Lyn Hejinian, *My Life*

This poem was chiefly written *[p.52]* Shelley, Preface to *Prometheus Unbound*

footsteps paved the world with light *[p.54]* Shelley, *Prometheus Unbound*

remarkable color effects *[p.55]* Museum wall text at Palazzo Massimo alle Terme

Infibulation of the male member *[p.56]* ibid.

Pull down thy vanity *[p.56]* Ezra Pound, "Canto LXXXI"

For me the greatest thrill *[p.59]* Sarah Manguso, *300 Arguments: Essays*

do not move stones *[p.59]* *If Not, Winter: Fragments of Sappho*, trans. Anne Carson

One should always be drunk *[p.63]* Charles Baudelaire, *Paris Spleen*, trans. Louise Varèse

Tiberius to the Tiber *[p.63]* Quoted in a presentation at Sperlonga, where Tiberius threw dinner parties in a cave; attributed to Suetonius

Here lies one whose name was writ in water *[p.64]* Engraved in Keats' gravestone at the Protestant Cemetery in Rome

Didactic poetry is my abhorrence *[p.68]* Shelley, Preface to *Prometheus Unbound*

irritable reaching for the truth *[p.68]* paraphrasing Keats, who wrote in a letter to George and Tom Keats, December 1817: "I mean Negative Capability, that is when man is capable of being in uncertainties, Mysteries, doubts, without any irritable reaching after fact & reason"

a fine basket for conveying apples and oranges *[p.71]* Richard Kenney used this phrase during a lecture to indicate the limitations of language.

Beauty obliterates all other consideration *[p.76]* ibid: ". . . with a great poet the sense of Beauty overcomes every other consideration, or rather obliterates all consideration"

we're told that violet pigments *[p.77]* Museum wall text at the Villa Farnesina

What a great artist dies in me *[p.83]* Hibbert, quoting Suetonius

Am I to have no other *[p.84]* Giorgio Vasari, *The Lives of the Artists*

They were peasants *[p.85]* Johann Peter Eckermann, *Conversations with Goethe*

Cezanne's father would agree *[p.86]* Ambroise Vollard, *Cezanne*, quoting *The Correspondence of Emile Zola, Early Letters*, Fasquelle, 1907

The most famous of Cavallini's mosaics *[p.87]* The man we consider our first art historian, Giorgio Vasari, claimed that Cavallini learned

about perspective and naturalism from Giotto—never mind that he was twenty years Giotto's senior. When Vasari (a Tuscan) attributed the fresco cycle in Assisi circa 1300 to Giotto (also a Tuscan), our first art historian effectively handed Giotto (and Tuscany) credit for the birth of the Renaissance. After five centuries taking Vasari at face value, art historians now challenge this story. Many scholars assert that artists working in Rome around the turn of the fourteenth century (including Cavallini) brought naturalism back to art, kicking off the Renaissance, and that Giotto was actually Cavallini's pupil. These Roman artists worked more often in mosaic than paint, but Vasari largely ignored mosaics in his story. Many crucial mosaics were destroyed in fires anyways, or covered over during remodels. In the process, history largely abandoned mosaics and Pietro Cavallini.

In a ceiling fresco *[p.90]* Museum wall text at Villa Farnesina

a border of large festoons *[p.91]* Museum wall text at Villa Farnesina

Whatever you have to say *[p.93]* Charles Olson's "These Days"

ILLE HIC EST RAPHAEL *[p.93]* Wall text at the Pantheon, translation by the authors

There is no place that does not see you *[p.97]* Rilke, "Archaic Torso of Apollo," trans. Stephen Mitchell

Aesthetics is the instrument *[p.98]* Richard Kenney, in conversation

we may ponder which metamorphosis *[p.109]* Charles Scribner III, *Bernini*

This fleeting world *[p.109]* Rilke, "Ninth Elegy" (paraphrase by the authors of Stephen Mitchell's translation)

Mr. Keats' hair *[p.111]* Wall text from the Keats-Shelley House

savage criticism *[p.115]* Shelley, Preface to "Adonais; An Elegy on the Death of John Keats"

the poor fellow *[p.116]* Shelley, Preface to "Adonais"

the death of me *[p.116]* Engraving on Corso's headstone in Rome's Protestant Cemetery

It might make one in love with death *[p.117]* Shelley, Preface to "Adonais"

Acknowledgements

THE IDEAS REPRESENTED HERE don't just belong to this book. They belong in part to an inquiry (ongoing for several decades now) instigated by poet Richard Kenney at University of Washington's Creative Writing program in Rome. We have been fortunate enough to dip in and out of this program over the years, to lesser and greater degrees. From the bottom of our hearts, we thank (and raise a round of negronis to) both Richard Kenney and Carol Light for weaving us into the fold of that conversation. We hope this book feels like a tribute to you both and to the program itself.

Abbracci go out to the entire Summer 2017 cohort, and to the Rome Center staff for treating us so well. In addition, we are grateful to the many voices we feel our book is in concert with, the generations of "Romies" past and present who have also engaged these ideas and questions in their own way.

Thanks to Reb Livingston for printing excerpts from *The Last Mosaic* in *Queen Mob's Teahouse*.

And lastly we'd like to thank Jacob Smullyan and the folks at Sagging Meniscus for their patience and vision in helping our manuscript both reach its final form and flutter out into the world.

Elizabeth Cooperman is co-editor (with David Shields) of the anthology *Life Is Short—Art is Shorter* (Hawthorne Books, 2014). Her work has appeared in *Writer's Chronicle, Seattle Review, 1913: A Journal of Forms*, and other journals. She has attended the Ragdale Foundation Residency, as well as the 360 Xochi Quetzal Residency Program in Chapala, Mexico, as artist-in-residence. Elizabeth is Art Director at *PageBoy Magazine*, and teaches sporadically as an adjunct professor in the University of Washington's English Department.

Thomas Walton is author of the anti-lyric-essay lyric essay *The World Is All That Does Befall Us* (Ravenna Press, 2018) and the micro-chapbook *A Name Is Just A Mane* (Rinky Dink, 2016). His work has appeared in *ZYZZYVA, Delmar, Timberline Review, Rivet, The Chaos Journal, Queen Mob's Teahouse, Bombay Gin, Pontoon,* and other magazines. Some of his poems were anthologized in *Make It True; Poetry from Cascadia* (Leaf Press, 2015). He lives in Seattle, where he edits *PageBoy Magazine.*